Freelance Jobs for Freelance Photography Business Start Up

Get Freelance Photography Business Secrets for all Types of Photography!

By Brian Mahoney

Get Our Video Training Program at:

**(Zero Cost Internet Marketing complete 142
video series)**

https://goo.gl/i9pRpP

http://www.briansmahoney.com/

ABOUT THE AUTHOR

Brian Mahoney is the author of over 100 business start-up guides, real estate investing programs and Christian literature. He started his company MahoneyProducts in 1992.

He served in the US Army and worked over a decade for the US Postal Service. An active real estate investor, he has also served as a minister for the Churches of Christ in Virginia and Michigan.

He has degree's in Business Administration and Applied Science & Computer Programming.

His books and video training programs have helped thousands of people all over the world start there own successful business.

Http://www.briansmahoney.com

DEDICATION

This book is dedicated to my brother
Ulester Love Mahoney Jr.
A blessing from God and kind loving Man.

Table of Contents

ACKNOWLEDGMENTS

I WOULD LIKE TO ACKNOWLEDGE ALL THE HARD WORK OF THE MEN AND WOMEN OF THE UNITED STATES MILITARY, WHO RISK THEIR LIVES ON A DAILY BASIS, TO MAKE THE WORLD A SAFER PLACE.

Disclaimer

This book was written as a guide to starting a business. As with any other high yielding action, starting a business has a certain degree of risk. This book is not meant to take the place of accounting, legal, financial or other professional advice. If advice is needed in any of these fields, you are advised to seek the services of a professional.

While the author has attempted to make the information in this book as accurate as possible, no guarantee is given as to the accuracy or currency of any individual item. Laws and procedures related to business are constantly changing.

Therefore, in no event shall Brian Mahoney, the author of this book be liable for any special, indirect, or consequential damages or any damages whatsoever in connection with the use of the information herein provided.

Chapter 1: Overview

What Photographers Do

Photographers are usually creative people with a good level of technical expertise to use cameras to take images of objects or events. Many photographers stand or walk and can carry heavy equipment.

Photographers usually:

* Promote their services to genterate business

* Plan the setting for the photographs

* Set up lighting equipment

* Use tested formulas for commercial level photos

* Use lighting to optimize the best photograph

* Use top quality photography software

* Keep a portfolio of their work for future clients

Film cameras used to be the standard, but today the majority of photographers use digital cameras to get electronic images. Electronic images and be edited on a computer. Images are stored on memory cards or computer hard drives and even flash drives. Once the image is on a storage device, photography software can then be used to manipulate and improve the image. With high quality printers, great photographic images can then be created. According to Techradar.com these are the top 10 digital cameras.

Camera	Retail Price
Canon EOS 5D Mark IV	$3,499.00
Fuji X-T2	$124.07
Nikon D500	$1,796.95
Sony Alpha A7r II	$2,949.99
Nikon D3300	$355.99
Panasonic Lumix LX100	$578.70
Olympus OM-D E-M10 II	$549.00
Panasonic Lumix ZS50 /TZ70	$331.00
Canon EOS Rebel T6i / 750D	$549.00
Panasonic Lumix FZ1000	$690.00

As you can see, the vary a great deal in price, which means almost anybody can afford to get started in freelance photography. Freelance photographers usually offer wedding, portait, framing and photo album services.

Self employed photographers also...

* Must promote their business

* Handle appointments

* Purchase supplies

* Set up equipment

* Keep Records

* Handle billing

* Pay business expenses

* Maybe hire and train employees

As a freelance photographer you can also teach photography classes and conduct photography workshops, in various learning institutions.

Here are some of the most popular types of photography:

* Portait Photography

* Commercial and Industry Photography

* Aerial Photography

* Scientific Photography

* PhotoJournalistic Photography

* Artistic Photography

* College Academic University Photography

Work Environment

According to the Bureau of Labor Statistics Photographers held about 124,900 jobs in the United States. Appoximately %60 were self-employed or freelance photographers.

The work environment for photographers depends on what field of photography they are in. Portrait photographers usually work inside of studios, and many times must travel to a school, corporate office or private residence. A photojournalist may have to travel all over the world, and often to dangerous places. Aerial photographers usually have to fly in planes or helicopters. Scientific photographers can also be tasked to travel internationally for their craft. While University and Artistic photography is usually done with less travel and in the comforts of indoors.

Work Schedules

Thirty percent of photographers work part time with flexible work schedules. The season of the year often determines the demand for certain types of photography. Weddings usually occur in the spring and summer and amazing winter and fall photos have to be taken in those seasons.

Photographers who work for corporations may have the usual 9 to 5 hours, but news organizations may require a photographer at any time a story breaks.

How to Become a Photographer

You do not have to attend college to become a photographer. If you have talent with a camera, it is a good idea to keep a portfolio of your work and present it as proof of your skill. Many freelance websites have competition between freelancers to determine who they will hire.

Even though postsecondary education is not required, many photographers still learn a great deal of their craft by attending bachelor degree programs or vocational and technical school's certification programs.

Entry-level positions in photojournalism or in industrial or scientific photography generally require a college degree in photography or in a field related to the industry in which the photographer seeks employment. For example, classes in biology, medicine, or chemistry may be useful for scientific photographers.

Business, marketing, and accounting classes can be helpful for self-employed photographers.

To be a successful freelance photographer you should possess these skills...

* Artistic ability. A feel for lighting, color combinations and environment.

* Business skills. The ability to make a business plan, manage money and clients, and purchase the proper equipment and be able to focus and prioritise.

* Computer skills. With digital photography, it is now a must to be able to use photo editing software and have computer skills to post resumes and market your business with websites and even YouTube videos.

* Customer service skills. Whether it is dealing with difficult and demanding clients or unruly childred or crying infants, the ability to show patience, compassion and a high level of professionalism is extremely important if you are going to be a successful freelancer who gets repeat work.

PAY

The wage for the top %10 of photographers was approximately $35.00 per hour. The median wage was approximately $15.25 per hour.

Freelance photographers can bid for projects that are on online job sites and set their own salary. They can also set up their own website and set the prices for each job according to industry standards.

Good word of mouth can keep a photographer in high demand and allow for a higher salary for fees.

JOB OUTLOOK

Jobs and employment for freelance photographers is expected to grow about %10 over the next 10 years. Family's get older and require new portrait photos, corporations need good photographers for their advertising campaigns, and as the population of the United States continues to increase, so will the demand for wedding photography. Creating and selling stock photography is another industry that internet marketing can help you to tap into.

The following chapters will assist you, in helping to put you in a better position to succeed as a freelance photographer. For every action there is a reaction. Use your personal power to take massive action for your individual success.

Chapter 2: Introduction to Freelancing

All about Freelancing

A freelance worker is a person who seeks employment, usually on a temporary basis. Often time one short contract at a time. Sometimes a freelancer uses an agency that specializes in suppling labor for business clients or one could have their own business where work is bought to them. There are now plenty of websites that specialize in freelance work.

There are many industries that regularly use freelance workers: Writers, Web Developers, Computer Programmers, Editors, Music, Copywriters, Actors, translators, illustrators are some of the most popular fields, but the freelance industry can include many more occupations.

Freelance Application

Resent statistics from a Freelance Industry so what Freelancers list as their Primary Skill:

20% Design

18% Writing

10% Editing

10% Copy writing

8% Translating

5.5% Web Development

4% Marketing

Over the years the freelance industry has changed. Many industries now require clients to sign contracts. A freelancer may require a deposit from a client, and may also be required to provide a documented estimate of the work, depending on the client. Some freelancers may still work for free on one project in order to get paid on another project. Each Freelance website has a different set of protocols for their freelancers and their clients.

Freelance Payment

How do I get paid when I work freelance? How you get paid when you work freelance, depends on the industry that you work in. It depends on your skill level and your experience. It also depends on if you use a website to get your job or project. If you are getting your own jobs you can charge by the day, hour, rate or a per-project basis. You could also use a flat rate fee based on the market value of your work. Payment arrangements are made upfront and sometimes a percentage paid upfront is the custom, and the rest upon completion. More complex jobs may require a detailed contract with a payment schedule. One of risks of being a freelancer is that their is sometimes no guarantee of full payment.

Sometimes a writer or people in other artistic fields create work on their own and then seek a publisher for their work. They usually keep the copyright to the works and sell or license the rights to publishers in a time limited contract. Usually the work would be submitted to publishers as unsolicited query letters or manuscripts, and would get either a acceptance letter or rejection slip.

When you a create intellectual property under a freelancer situation (according to the publishers' or other customers' specifications) are sometimes referred to as "independent contractors" or other similar terms.

Section 101 of the U.S. Copyright Act of 1976 (17 USC §101). Details "works made for hire", protection of intellectual property is defined.

Demographics

A new era has begun. Nine to five has defined what many people traditionally think of as a job.

Times are quickly changing. Over 53 million Americans are now earning income from jobs that are considered freelance or independent contracting. That is %33 percent of the United States workforce.

The current increase in freelance work is similar the the Industrial Revolution of times past.

The surge in freelancing is more than two decades old at this point.

The freelancing increase began over twenty years ago, when with the increase in technology many more people were able to work from project to project. It was about that time that the Freelancers Union was formed by Sarah Horowitz.

 About 70% of the Freelance industry is made up of women between the ages of 30 to 50. So while the regular journalism field is made up predominately of men, the freelance writing profession is mainly women.

Benefits

Freelancers have many of reasons for freelancing, the profit gained differ by gender, industry, and way of life. Recently Freelance Industry Report reported that males and females do freelance work for different reasons. Women in the survey said that they prefer the scheduling freedom and flexibility that freelancing offers, while men in the survey said they freelance to follow or pursue personal goals.

Freelancing helps people to obtain greater levels of employment in isolated communities.

Workers who have been laid-off have decided to be freelancers because they can't find full-time jobs for some industries like the newspaper industrie which has been declining recently. Students have become freelancers using some of their free time during the school year. Flexibility is always rated high on blogs and in interviews on website.s

Drawbacks

Their is plenty of websites that specialize in Freelance work and offer plenty of advice and work for freelancers.

Freelancers usually live without job security. They also have deal with employers who don't pay on time. Freelancers usually don't have employment benefits such as pension, sick leave, paid holidays, bonuses or health insurance.

Answers to Drawbacks

The use of freelance websites can usually eliminate the problems with payments.

Using multiple freelance websites can stockpile tons of work to add to job security.

Because you are a freelancer and your own boss, you can give yourself sick leave and paid holiday.

Impact of the Internet

The power of the Internet has given freelancer many more job oppurtunities. There are growing markets for writers, editors, illustrators, graphic design, computer programmer, web developers and many more rising jobs.

Recent stories on CNBC and other news outlets show that online outsourcing and crowdsourcing are becoming more popular with many of the top websites like Upwork and Toptal with over a million clients. More companies are leveraging technology to fill labor shortages. Many compainies are even going outside of the United States for computer freelance work. Micro Work Sites like fiverr have become very popular.

This book will show you plenty of the top freelance websites and online marketplaces that match workers and clients using the internet. Most sites use a bidding service, fixed price or an hourly rate. Workers get paid through a merchant account supervised by the website. The website makes money by getting small percentage of each transaction.

With the internet the interview process and hiring for freelancers can be done without actually seeing the employer in person. This is amazing for being able to do long distance work all over the world. There is a drawback, because the screening process is less personal.

But the internet allows you to hire more than one person and test out their work. Fiverr is an exellent website to "test out talent" before committing to a big job. Especially for writing. With the explosion of the Amazon Kindle, many people are looking for internet writers to assist in creating content for books. With more and more blogs and webpages being put up, the demand for information technology continues to increase.

It is estimated that Amazon holds %67 of the online publishing business and %25 to Barnes and Noble. Amazon recently reported that their online electronic books have surpassed and even doubled the sales of their print books. So the need for writers has really exploided with the use of the Internet. The use of the internet and the Amazon explosion has also resulted in an increase in copy editing of book and book manuscripts and proofreading services being outsourced to freelance copy editors and proofreaders.

There are many top freelancer websites. We will go into detail about the top freelancer websites in another chapter.

A few Legal aspects

For legal advice in your business consult the appropriate professional.

Some newspapers allow a writer the option of ghost signing. That is when a writer does not use their name in the byline of their article. Ghost signing allows a writer to get benefits while still being classified as a freelancer. While ghost signing is a big issue in the UK(IR35 violations) it does not matter much in the United States.

Freelancers have to handle promotion, contracts, law issues and finance and business responsibilities by themselves.

Freelancers run the risk of losing too much of their profit and have to be careful of expenses when using other professionals in their business.

The United States Federal government in 2009 began to increase their montering of freelancers and other independent contractors.

The (GAO) United States Government Accountability Office instructed the Secretary of Labor to look at freelancers or independent contractors during targeted investigations. Their targeting involves appropriate employment taxes and unemployment and workers compensation.

Chapter 3: Ideas for Services to Offer

With a little bit of training you can share your experience, or college training with the world and make a nice income doing it. When it comes to being a freelancer you are not confined to what you have a degree in. If you have a skill use it. Some the best programmers I have met did not attend school but were self taught.

You can download open office for free

Go to the web resource guide for the website...

To create slides, ebooks, reports and PDF files.

You can download ScreenCast-o-Matic for free to create screen captor videos

Go to the web resource guide for the website...

Get Our Video Training Program at:

(Zero Cost Internet Marketing complete 142 video series)

http://www.ebay.com/itm/1997-MegaSized-Internet-Marketing-Copywriting-SEO-Course-1000-Bonus-/191806194334?

Ideas for Services to Offer

Consulting on Your Skill set

If you have a degree or a ton of experience on a skill set then why not make some money consulting for it. Often times people don't know how much they know until some one asks them questions. So interview yourself. Write the information down, and create a guide for consulting. After you are comfortable with your knowledge, then consult in the traditional way.

Writing:

ebooks, reports, articles, blog posts

Because of the growth of Amazon's Kindle Publishing there has been an explosion in publishing of ebooks. But many of the ebook publishers are frustrated with the poor quality of the freelance writers that they sub contract out for on freelance websites. If you have a way with the words, or just have a decent grasp of the english language, there are a ton of people who desire your services.

Graphics:

Photoshop Services is just one of the growing needs of internet businesses. With the explosion of online publishing there are many authors who are in need of graphic assistance in the form of book covers. If you have any skill in this area, this can be quite profitable. One of the most popular print on demand book sites is Createspace. Their book cover fees start at $199.00. I have written many books and done all of my covers. If you know what you are doing creating a good cover can be done in under an hour.

Videos:

Recording videos, editing Videos, Screen Capture Videos

If you go to fiverr you will see plenty of people who will make videos for you. Some people just don't want to be in front of a camera. You can view the gigs on fiverr to get an idea of what is in demand and make some money, making videos for YouTube. In the web resource section of the book I show you free tools that you can use to make professional videos that can help you in your freelance business or help your potential clients in their business in just minutes.

Wordpress:

setup of blogs - themes, plugins, posting content on the blog, writing blog posts

Web design:

Building websites. Later on in this book I tell you about some free web hosting websites. With a little bit of practice they are really easy to use and set up webpages. However many people are really still intimidated by the internet an desire someone else to set up their webpage. This gives you an opportunity to make some good money quickly and easily by setting up websites. I even tell you how to add e-commerce to a website for free, saving your potential clients even more money.

Social media:

twitter, facebook, linkedin - social engagements

Social media is a big component of SEO. Search Engine Optimization. If you are good with social media you can use this skill to build back links and to promote businesses.

Blog and forum commenting:

posting relevant and non spammy comments on relevant blogs for forums.

One of the ways for your to expand your freelance business is to post on forums. You could help others expand their business as well, by learning the best forums for their business. I give you a list of top forums in this book.

Consulting: works for all niche markets outside of your own. Just do research on other topics that interest you.

Technical setup: setting up sales pages, squeeze pages. I tell you how to do this with Paypal later on in this book.

Recruiting JV partners: can email potential JV partners for a fee or cut of sales.

Business plan creation

People pay a fortune for business plans. There is business plan software available that will make you a business plan expert. Help expiring business owners get started by guiding them with a great business plan.

Resume writing

Many people have absolutely horrible resumes up. Do your research. There are plenty of websites even YouTube videos that show you how to write and publish a good resume. Use this information for yourself, then get paid to teach it to other. Fiverr is a great website to do this service.

Tutoring help

There are all kinds of students who need tutoring help. There are older students returning to college who need help with today's technology, and there are always a ton of student who either struggle with writing or mathematics. If you are good at either there is a huge market for you to tap into.

Lawn care advice, Shopping advice, Travel planning

Wikipedia has a huge section on their website devoted to lawn care. Even a novice could understand it and help others who wish to learn how to better care for their lawn.

With so many travel sites to choose from, many people are overwhelmed. Do a little research and help busy people concentrate on doing what they want. Travel.

With e-commerce sites like Amazon and Ebay there are always good deals on the internet. But did you know that there is data mining software that helps you find the best deals on the internet? This software is expensive, so you might just want to do the work yourself. In addition there is a website called Salehoo.com that has a database of about 10,000 wholesalers and drop shippers. You are bound to find some amazing deals on this website. Salehoo is not free. They have a lifetime membership fee that was around $70 at last check.

Consulting on speaking

If you are a good speaker then you could consult others on how to prepare for a speech as well as deal with any fears of public speaking.

Bookkeeping - quickbooks services

With so many accounting software options out there, many you may have already learned how to do your own taxes. You may also be able to use accounting software to help small businesses or other independent contractors with their accounting issues.

Chapter 4: A Winning Profile

BEST PRACTICES

How to create a winning profile

* Have a good headline

* Limit to one line.

* Include position title, number of years experience, specialty.

* Graphic Designer - 3 Years Experience - Photoshop

* If you are new to your profession include your top qualities.

* Use a professional looking photo.

* Blank wall with good lighting of just your head.

* Look friendly and professional.

* Make sure it is only you in the picture.

* Have a strong opening paragraph.

* Open with your qualifications.

* Tell them what makes you a good candidate.

* Look at other top profiles

* **Discuss your academic background if applicable**

* If you have a college degree or advanced degree mention that.

* Not the end of the world if you do not.

* Use samples of your work

* Have links to samples of your work in your portfolio.

* Some profiles let you attach work samples.

* Writers provide multiple articles your have written.

* Designers use links and images of designs you have done.

* If you are new this is your chance to stand out.

* Follow rules on Freelancing sites

* Be careful about posting your full contact details in your bids and posts.

* Some freelancing sites do not allow this.

* Use their messaging feature in that case.

* After the project is won by you, they typically give up full contact details.

* You don't want to get yor profile shut down or suspended unintentionally.

Have your own website or page online about your services.

* Use About.me to set up a free web page.

 • Post your resume and links to examples of your work.

 •

* Use Weebly.com for a free website.

* Use Wix.com for a free website.

Social Media Accounts

* Get active on social media.

* Facebook, Twitter, LinkedIn, GooglePlus, Pinterest

* Use a semi-professional photo on your social media profiles.

 • Mention you are a freelancer on you profiles.

 •

Use Social search on Twitter

* "freelance **Your Occupation** wanted"

* "freelance **Your Occupation** needed"

* Setup Google Alerts – google.com/alerts

* So that you are the first to know about new jobs or opportunities.

* Ensures you don't miss any opportunities.

* Setup Talkwalker Alerts – talkwalker.com/alerts

*Have these sites Monitor web for keywords:

 * "freelance **Your Occupation** needed"

 * "freelance **Your Occupation** wanted"

Partner up

* web designers and developers need content writers or copywriters in **your occupation**.

* Marketing consultants need graphic experts.

Talk about your expertise @ clarity.fm

* Only do this if you are an expert!

* Let's you charge between $1 and $10 per minute of your time.

* This may open up additional opportunities down the line.

Bidding on Jobs Strategies

* On most freelance sites you bid on the jobs.

* Don't go for your highest rate when you start out.

* You may need to work for a discount to buildup hours worked and feedback.

* Your feedback and hours worked will make new jobs much easier.

* Work on smaller projects to build up a client base.

* Make sure you have samples of your work to present regardless of your expertise.

* Start bidding and getting Yourself out there.

Chapter 5: The Best Job Freelancing Sites

1. Upwork

With over 1.5 million clients and over 9 million registered users Upwork (formerly oDesk) likely has something for you regardless of where you are in your career. Upworkd is good for small and big projects. Upwork has hourly projects as well as per project gigs. There are jobs for experts as well as entry level. This is the larges freelancing website on the market.

Because of the massive size of this website, many of the jobs have a lot of competition which leads to low bid contests. The site also has fixed bids as well. It is a good strategy to lower your usual rate to get some jobs and build up a good reputation and rating on the site.

2. Toptal

*Unparalleled access to meaningful projects with great clients and fair compensation.

Toptal is more for freelancers with experience. Toptal has a screening process you have to pass and which leads to high level fortune 500 clients. The compensation is fair with no low bid contests. Toptal also has frequent meetups and tech events.

This website has been constructed for top of the line software engineers that must pass a difficult screening process. Toptal is looking for people with experience, good communication skills as well as a high level of technical know how. Toptal offers a risk free trial period. Once accepted you can set your own hourly rates.

3. Elance

As of the printing of this book (2016), the Elance website is still up, but it has merged with Upwork.

4. Freelancer

Freelancer is a big platform with lots of clients. In addition to offering millions of projects, freelancer allows you to compete with other freelancers in contests to prove your skills, showcase your abilities, and attract more clients.

If you are just starting out, because of the contests, and the large number of competitors might make this a website to try later on in your career.

5. Craigslist

Craigslist is more than just a website to buy and sell household products and personal belongings. It is also a great source for freelance jobs. You can easily browse local offerings or you can search by major cities if you prefer working remotely.

While Craigslist is not a freelance only jobsite it's size makes it a great cost effective place to find freelance jobs.

6. Guru

Easily showcase your past work experience and use the daily job-matching feature to avoid missing any good opportunities.

Guru has a work room designed to let you manage all of your work, quickly and easily.

At first Guru focused on the United States, but now Guru is global website that is constanly expanding.

Guru primarily deals with computer programming coding but other professions are represented too.

Guru has great project tracking features but also has high fees and a challenging withdrawal system, that you could incur more fees. Particularly with smaller jobs.

7. 99designs

This is a great website for freelance designers. 99designs allows you to compete in design contests and get feedback as clients choose the best ones. A great way for talented designers to prove their skills. Be careful to protect yourself from plagiarism when using this website.

8. Peopleperhour

Peopleperhour A great platform, focusing on freelancing for web projects. If you're a designer, developer, SEO specialist, etc., This site is worth checking out.

This website can have high fees and challenging customer service support.

9. Freelance Writing Gigs

Freelance Writing Gigs. The name almost says it all. This is a website for publishers, writers, editors, bloggers or any one who has talent with words.

10. Demand Media

Demand Media is a website for creative types to promote their talent, including writers, filmmakers, producers, photographers, and more.

This a a great website For Clients that need these types of creative people.

11. College Recruiter

The college student or recent graduate often is faced with the delima of not having experience when searching for a job. Well, the College Recruiter website is for college students or recent graduates looking for freelance jobs of any type.

College Recruiter is a great place to get a jump on your career or earn some money doing part time work.

This is a website usually for smaller projects that can be done by people that do not have a lot of experience.

12. GetACoder

GetACoder is a freelancing website that focuses primarily on small projects for computer programmers, writers, web developers. This is an excellent website for freelancers that don't want to be loaded up with long term (three to six month) projects.

13. iFreelance

Unlike other sites, iFreelance is a freelancer website that allows you to keep 100% of your earnings. It accomodates writers, editors, coders, and even freelance marketers.

14. Project4hire

Project4hire has a ton of job categories. Easily identify jobs that suit your skillset with hundreds of project categories to choose from.

This website is primarily for computer programmers, consultants and designers. Although there are jobs for other professions.

15. SimplyHired

SimplyHired is a freelance website that is not focused on tech but has a wider range of jobs than most. This site is perfect for anyone from salespeople to construction workers.

SimplyHired has a blog with hiring tips, a company directory and location-based search. This is the perfect website for people whose skillset is not technology based.

16. Staff.com

Staff.com is a freelance website that is primarily for long term freelancers. Staff.com is smaller that some of the other websites in this list and gives freelancers looking for more stable work a place to go to.

17. LinkedIn

LinkedIn is a well known professional network. It features a large collectiong of resumes and professional profiles. There are many options on this website to help you increase your exposure for professional work. There are also professional courses to help you to maximize the many features on this website.

18. StackExchange

StackExchange is not a website that is dedicated to freelance workers. It does have a extremly popular Questian and Answer forum that can be used to connect with freelance or independent contractor and employers. It could take more work than other websites, but is still a place were a freelancer can network to get a job.

19. Jobs.smashingmagazine.com

An excellent portal for developers and designers to find freelance jobs.

20. FLEXJOBS.COM

This freelance website stands out by vetting jobs, not freelancers. In return, flexjobs provides a job list of just under 30,000 projects with contact information.

Whether you are a computer programmer, web designer, experienced, or just out of college or something in between, there is a freelance platform out there for you.

This website also has skill testing and job search tips.

Chapter 6: Micro Job Sites

Micro job sites or small gig sites aren't full blown freelance sites. They are an excellent way to kickstart your freelance career or income. Provide small tasks that you can get paid a smaller fee for.

For example:

* Writing one article instead of 10 or 20.

* Creating one logo instead of multiple ones.

* Create a short testimonial video.

* Do keyword research.

* Design ebook covers.

* Install Wordpress.

* Install a support desk.

* Become a virtual assistant.

* Transcribe a short audio file.

* Give advice about your occupation.

* Create PDF files.

* Master audio tracks.

* Teach lessons.

* Send video message.

 * Paint/draw.

Fiverr

The world's largest marketplace for services, starting at $5.

Fiverr is a global website that started in February of 2010 and is offering small jobs, projects and services beginning at a cost of $5 per job. This freelance outsourcing website is primarily used by freelancers who use Fiverr to offer services to customers worldwide. Currently, Fiverr lists more than 3 million services or jobs on the site that range between $5 and $500.

Fourerr

Fourerr is a freelance website similar to fiverr, except the jobs start at $4.

seoclerk

Seoclerk is a freelance website that has thousands of SEO (Search Engine Optimization) experts and services that start at just $1!

Chapter 7: Short Jobs

Some of these freelance websites are can have all types of small jobs some very profession some not professional at all. The pay is very small, but it could add up.

Mturk.com

(this is a Amazon owned site for very small jobs like retweeting a tweet for fifty cents or some other low fee.)

clickchores.com

Is currently undergoing renovations. These are very small tasks like, liking a facebook page.

Talkwalker.com

clarity.fm

gigbucks.com

(Has micro job requests all types of jobs, dating advice, business, programming, tips and advice, etc)

imgigz.com

(Internet Marketing article writing, backlink jobs, freelance website)

Chapter 8: Forums and Payment

You can go to online freelance forums for great information. Some of the top forums are...

forums.digitalpoint.com/ (looking for hire)

If you are looking for (or offering) services, this is the forum to use. This includes job listings, etc.

wjunction.com (wanted members)

Has a ton of affiliate programs that you can make money on.

warrior.com (warriors for hire)

Maybe the most well known forum on the internet.

talkfreelance.com

Pretty good freelance forum in terms of content; caters to a several industries for freelancers like graphic designers, programmers and photographers; plus points for the site's ease of navigation.

whydowork.com

Highlights work-at-home opportunities, as well as other freelance activities; has a forum where members can share and discuss scam reports — really helpful feature

https://studio.envato.com/freelance-switch/

Easy browsing; most recent posts are listed in a separate field and updated in real time (shows time elapsed) so fresh topics are easy to find; focuses more on the practice of freelancing than the job industries

Accepting Payments

Most freelance sites take care of payments for you.

Micro job sites do the same.

Work you find on Craigslist, classifieds, or on forums will require a payment system.

PayPal

PayPal Holdings, Inc. is an American company operating a worldwide online payments system. Paypal was started by the genius Elon Musk. Who is currently building spaceship(SPACEX) to fly to Mars as well as developing affordable electric cars(TESLA).

Paypal if free to join and and charges transaction fees of about 3% when you make a sale. Paypal is the most popular payment site in the world.

Sometimes web hosting websites charge you extra fees for setting up a e-commerce web page. But with Paypal you can do this yourself rather easily.

You go to the merchant section of Paypal and create a Payment button. You can then cut and copy the HTML code for the payment button. Then paste the code, often with the wiget functions on your website. Website editors vary, but with some practice it can be done. This will save you monthly fees and increase your bottom line and profit margin.

BlueSnap

Formerly called Plimus

Website https://home.bluesnap.com/

BlueSnap is a worldwide payment system and merchant account provider based in the great state of Massachusetts.

For two years running BlueSnap has won the CNP Expo Award for Customer's favorite in the Best Alternative Payment Solution and Best Subscription /Recurring Billing Solution categories.

Chapter 9: Always Ready

You can create a free website using wix or weebly to send to keep your resume information or contact information always available for potential employers.

As mentioned before you can use Google Alerts to keep you posted on potential jobs.

Google Alerts

Google Alerts sends you an email alert every time it detects content you instructed it to look for. The service is offered by google.

Start by going to...

https://www.google.com/alerts

In the box at the top, enter a topic you want to follow.

- To change your settings, click **Show options**. You can change:

- How frequent you get notified
- The kinds of websites you'll see
- The language you get your alerts in
- Which part of the world you want alerts from
- How many alerts you will to view
- What accounts get the alert

- Hit **Create Alert**. And you will get emails whenever they find matching search results.

https://www.weebly.com/

Weebly was created on March 29th 2006. Weebly is a free web hosting servicer that features a drag and drop web page editor.

Product

Weebly's free online website maker uses a easy site builder that operates in the web browser.

There are basic features like accepting payment and creating blogs that is supported by this website

Weebly has been featured in Time Magazine as well as The Wall Street Journal as a top 50 website. As well as the Wall Street Journal

https://about.me/

About.me allows you create a free one page website in just a few minutes. It can be your resume or your address on the web. This is an amazing resource to keep you information out on the web for free. It also allows you to stand out from the crowd because only your information is on the website.

Wix.com

Wix.com is a free cloud based website where people can design a webpage using their drag and drop system. The user can make HTML5 web pages. Users can also add many functions to their site. Some of the functions that can be added are Social media plug ins, forms for contact as well as e-mail marketing.

The plug-ins is a business model that Wix used to generate income. The purchase of these add ons as well as additional data for storage and bandwidth, are costs you should be aware of as you count the cost of this "free" website as compared to others.

All this information helps to give you an edge on your other freelance competion. In the words of Actor Will Smith. "If you stay ready, you don't have to get ready." Show potential employers that you take the iniciative, and stay prepared to perform.

Chapter 10: Web Resources

Get Our Video Training Program at:

(Zero Cost Internet Marketing complete 142 video series)

http://www.ebay.com/itm/1997-MegaSized-Internet-Marketing-Copywriting-SEO-Course-1000-Bonus-/191806194334?

http://www.briansmahoney.com/

Free Information Creation Tools

You can download open office for free

https://www.**openoffice**.org/**download**

To create slides, ebooks, reports and PDF files.

You can download ScreenCast-o-Matic for free to create screen captor videos

https://screencast-o-matic.com/screen_recorder

Always ready Free Web Hosting Sites

www.weebly.com

www.wix.com

www.about.me

Automatic Alerts

www.google.com/alerts

www.talkwalker.com/

Top Freelancing Job Sites

https://www.Upwork.com

https://www.TopTal.COM

https://www.Jobs.smashingmagazine.com

https://www.Freelancer.com

https://www.Craigslist.com

https://www.Guru.com

https://www.99designs.com

https://www.PeoplePerHour.com

https://www.Freelancewritinggigs.com

https://www.Demandmedia.com

https://www.Collegerecruiter.com

https://www.Flexjobs.com

https://www.Ifreelance.com

https://www.Project4hire.com

https://www.Simplyhired.com

https://www.staff.com

MICRO JOB SITES

https://www.fiverr.com/

https://www.fourerr.com

https://www.seoclerks.com

http://www.clickchores.com/

Forums Freelancers can use

https://forums.digitalpoint.com/
(looking for hire)

http://www.wjunction.com/
(wanted members)

http://www.warriorforum.com/
(warriors for hire)

http://www.talkfreelance.com/

http://www.whydowork.com/

https://studio.envato.com/freelance-switch/

Payment Sites

www.paypal.com

https://home.bluesnap.com/

Getting Started

Step by Step

Getting Started in Your Home Business

There are thirty eight million home-based businesses in the United States alone.

Many people dream of the indepence and financial reward of having a home business. Unfortunately the let analysis paralysis stop them from taking action. This chapter is design to give you a road map to get started. The most difficult step in any journey is the first step.

Anthony Robbins created a program call Personal Power. I studied the program a long time ago, and to I would summarize it, by saying you must figure out a way to motivate yourself to take massive action without fear of failure.

2 Timothy 1:7 King James Version

"For God hath not given us the spirit of fear; but of power, and of love, and of a sound mind."

STEP #1 MAKE AN OFFICE IN YOUR HOUSE

If you are serious about making money, then redo the man cave and make a place for you to do business, uninterupted.

STEP #2 BUDGET OUT TIME FOR YOU BUSINESS

If you already have a job, or if you have children, then they can take up a great deal of your time. Not to mention well meaning friends who can use the phone and become time theifs. Budget time for your business and stick to it.

STEP #3 DECIDE ON THE TYPE OF BUSINESS

You don't have to be rigid, but begin with the end in mine. You can become more flexible as you gain experience.

STEP #4 LEGAL FORM FOR YOUR BUSINESS

The three basic legal forms are sole proprietorship, partnership,

and corporation. Each one has it's advantages. Go to www.Sba.gov and learn about each and make a decision.

STEP #5 PICK A BUSINESS NAME AND REGISTER IT

One of the safest ways to pick a business name is to use your own name. You own name is not copywrited. Just google Tom Cruise. However, always check with an Attorney or the proper legal authority when dealing with legal matters.

STEP #6 WRITE A BUSINESS PLAN

This would seem like a no brainer. Even for a freelancer, you should have a business plan. In the NFL about seven headcoaches get fired every season. So in a very competetive business, a man with no head coaching experience got hired by the NFL's Philadelphia Eagles. His name was Andy Reid. Who would become the most successful coach in the team's history. One of the reasons the owner hire him, was because he had a business plan the size of a telephone book. Yours dones not need to be nearly that big, but if you plan for as much as possible, you are less likely to get rattled when things don't go as planned.

STEP #7 PROPER LICENSES & PERMITS

Go to city hall and find out what you need to do, to start a home business.

STEP #8 SELECT BUSINESS CARDS, STATIONERY, BROCHURES

This is one of the least expensive ways to not only start your business but to promote and network your business.

STEP #9 OPEN A BUSINESS CHECKING ACCOUNT

Having a separate business account makes it much easier to keep track of profit and expenses. This will come in very handy, whether you decide to do your taxes or hire out an professional.

STEP #10 TAKE SOME SORT OF ACTION TODAY!

This is not meant to be a comprehensive plan to start a business. It is meant to point you in the right direction to get started. You can go to the Small Business Administration for many free resources for starting your business. They even have a program(SCORE) that will give you access to many retired professionals who will advise you for free! www.score.org

Conclusion

As a freelancer you are not limited as you would be in the conventional workforce. Use this to you advantage. Many people, especially on the micro jobs websites don't care what your education is, they simply want somebody who can do the job they desire to be done. Many skill sets don't take four year degrees. Many technical institutes have risen up and proved that people can be trained professionals without taking other classes that don't relate to their chosen profession. With the massive library of training videos available on YouTube, you certainly can make money as a freelancer, having more than one skill set.

I have a complete set of training videos that teach you a completely zero cost way of not only marketing yourself, but any business you desire, on today's biggest marketplace. The Internet. Don't have a great day. Make it a great day. Make it a great life.

Get Our Video Training Program at:

(Zero Cost Internet Marketing complete 142 video series)

http://www.ebay.com/itm/1997-MegaSized-Internet-Marketing-Copywriting-SEO-Course-1000-Bonus-/191806194334?

Massive money for Real Estate @

http://www.briansmahoney.com/

Made in the USA
Monee, IL
08 July 2021